WOOLTON

HISTORY TOUR

COOKSONS

ACKNOWLEDGEMENTS

I wish to place on record my thanks to the many people who helped me gather information and photographs of Woolton, especially Ian Mowatt for sharing his wealth of knowledge of Woolton and Miss B. McKenzie who, many years ago now, gave me access to and permission to use so many of the photographs from her personal collection.

Much of the text of *Woolton History Tour* is based on my previous research about the area. Finally, while I have made every effort to ensure that the notes in this book are factually correct, any errors or inaccuracies are mine alone.

First published 2020

Amberley Publishing
The Hill, Stroud,
Gloucestershire, GL5 4EP
www.amberley-books.com

Copyright © David Paul, 2020
Map contains Ordnance Survey data
© Crown copyright and database
right [2020]

The right of David Paul to be
identified as the Author of this work
has been asserted in accordance with
the Copyrights, Designs and Patents
Act 1988.

ISBN 978 1 3981 0207 1 (print)
ISBN 978 1 3981 0208 8 (ebook)

British Library Cataloguing in
Publication Data.
A catalogue record for this book is
available from the British Library.

Origination by Amberley Publishing.
Printed in Great Britain.

INTRODUCTION

Much has been written about the changes of landownership in and around the ancient village of Much Woolton, and still more make reference to the changes in name that Woolton has seen since the time of the Domesday Book. As early as 1188 the village was known as Ulventune, Uvetone or Wlvinton, and later, in 1341, Wolvinton, Wolveton or Wolfeton. The names Wolton and Wollouton are in evidence from 1345, and then Miche Wolleton from 1429.

In 1066, four manors were recorded in the area. These were Ulventune, which comprised two plough lands and half a league of wood. The land was held by Uctred for the customary rent of 64d. Wibaldeslei, also having two plough lands, was held by Ulbert, who also paid the princely sum of 64d to farm the land. The other two manors, known as Uvetone, had one plough land and were held by two thegns.

In 1338 the Hospitallers established a camera at Woolton, and the estate, including 50 acres of land, 5 acres of meadow and a watermill, remained under their jurisdiction until the English branch of the Hospitallers was suppressed by Henry VIII, who took the manor into the Crown's estates. In 1609, James I gave the land to George Salter and John Williams as part payment of an earlier loan. Shortly afterwards, the land was transferred to the Earl of Derby.

The farming and upkeep of the lands remained much the same over the following centuries, although the lands changed owners on a number of occasions. It was not until the advent of the Industrial

Revolution and the burgeoning growth of the nearby town of Liverpool that significant changes began to happen in the village.

Many of the changes that occurred were due to the hand of James Rose, a local man born in 1783. He changed what has been described as barren heathland into cultivated farmland and parkland. He also built a windmill and, later, a mill-house. Among his other business interests, James Rose was a quarry owner and built some fine sandstone mansions in the village, notably Beechwood and Rosemount. He was also instrumental in the building of Church Road, Rose Street and Rose Brow, which is on the edge of the village. James Rose is buried in St Peter's churchyard.

In 1811, the population of the village is recorded as being 671, but, largely due to the efforts of James Rose, that figure was due to rise. Woolton was viewed as a desirable place to live by many of Liverpool's wealthy businessmen and shipowners, who not only moved their families to the village, but also brought in their wake large numbers of domestic staff and skilled craftsmen to augment the workforce already employed on the farms and in the quarries. By 1851 the population had risen to 3,699, a massive increase in just forty years. However, there were other contributory factors that led to the rise in population. During that period there was a significant influx of immigrants from Ireland due, in part, to the famine in that country.

Churches began to establish a presence in the village. The first Roman Catholic church of St Mary was opened in Watergate Lane in 1765. Later, when James Rose built Church Road, the Anglican church of St Peter was consecrated in 1826, and then, in 1834, a Wesleyan chapel was built. However, because of the continuing rise in population in Woolton, a new and larger cruciform church was built in 1860, and the new

church of St Mary was opened. Then, in 1864/5, the Wesleyans moved to their new church of St James in High Street, which is where a new Congregational church was also built. The foundation stone of the new and greatly enlarged Anglican church was laid in 1886, and the church was consecrated the following year. Like most of the other prominent buildings in Woolton, the church was built of local sandstone.

During this major period of change, children from the village continued to be educated at the old school in School Lane. A second school building opened in 1823 and gave additional provision in the village. In 1848, another school building was opened, thus making the old school in School Lane redundant.

In the twenty-first century the village of Woolton stands as a testament to everything that is solid and of worth, while concurrently espousing every positive aspect of present-day living. Hopefully the images and text in *Woolton History Tour* will help to give context to that claim.

KEY

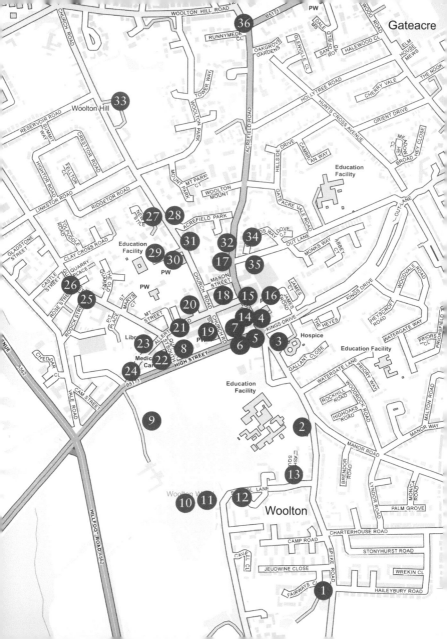

1. WOOLTON GOLF CLUB

The history of Woolton Golf Club is rich and proud. It was in 1899 that Lewis Samuel Cohen, a director of Lewis's Limited, purchased Doe Park, an estate of some 45,428 acres. His sole purpose in buying the house and estate was to create and establish a golf club. The course was ready for play towards the end of 1900 and, at that time, boasted nine holes.

It was always the intention to extend the course to eighteen holes. In 1906, news broke that land to the north side of Speke Road was up for sale, but other parties were interested in acquiring the land. In a race to secure the purchase, two men, carrying the whole of Lewis's takings for the weekend, raced onto the London-bound train at Lime Street station and stayed overnight in London. Early next morning (Monday) they were able to pay, outright, the purchase price of the land minutes before their rival would-be purchaser arrived at the solicitor's office.

The club has long been established as one of the premier clubs in the north-west of England.

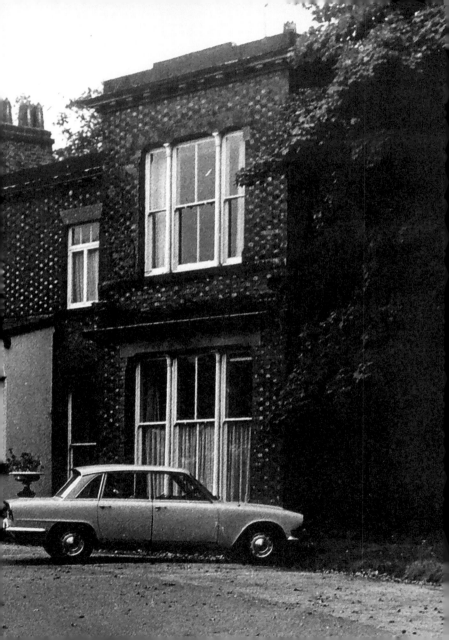

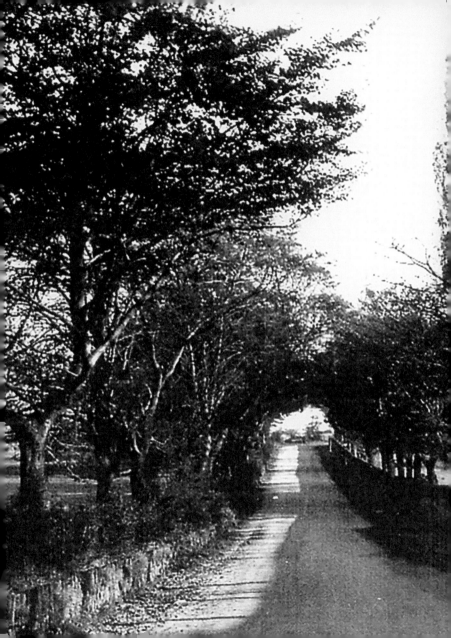

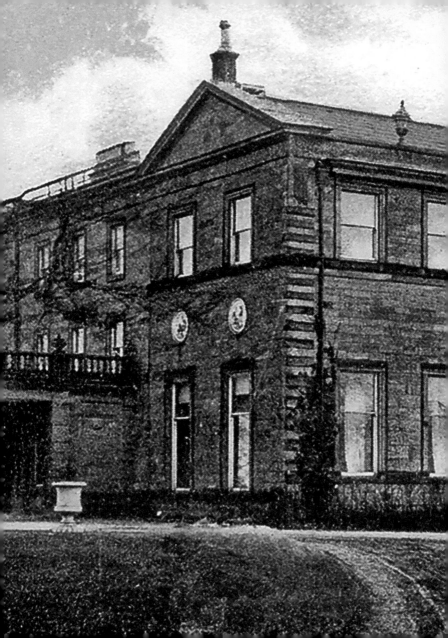

2. WOOLTON HALL

From late in the twelfth century until the Dissolution of the Monasteries during the reign of Henry VIII, the land upon which Woolton Hall was built was held by the Knights Hospitaller. The land was later restored by Mary I, but then finally confiscated during the reign of Elizabeth I. From 1559 until 1609 the land was held by the Crown and, sometime later, it was acquired by the Brettarghs of Holt.

When William Brettargh died, he left 'a cottage' in Much Woolton. The Broughton family succeeded to the lands some years later and by 1700 had built a three-storey house. The estate and hall were purchased at the beginning of the eighteenth century by Richard Molyneux, 1st Viscount Molyneux. The north wing of the hall was built in the following year when Molyneux married; in all probability the stone used was taken from the sandstone quarry in Woolton Woods.

The High Sheriff of Lancashire, Nicholas Ashton, purchased the Woolton Hall estate in 1722 and, very soon afterwards, engaged no less a figure than the celebrated architect Robert Adam to completely reconfigure the property. On Ashton's death in 1833 he left the hall and estate to his son Joseph Ashton, who, in turn, left it to his son Charles Ellis Ashton. In 1865 the estate was sold to prominent local businessman James Reddecliffe Jeffery. Then, in 1877 the property was bought by Sir Frederick Richards Leyland, a shipowner. He later sold the property to another family of shipowners, the McGuffies.

In the 1950s the hall was used as an army hospital and later converted and used as a fee-paying school for girls. After merging with another girls' school the decision was taken to move the significantly larger school, St Julie's Catholic High School, to a completely new premises. The abandoned building was bought by local resident Mr John Hibbert, who spent a vast amount on completely refurbishing the building. Plans were later drawn up to convert the hall into retirement care apartments.

In the late afternoon of Thursday 30 May 2019, fire crews were called to the hall where a huge blaze was engulfing the building.

3. THE LIVERPOOL AND BOOTLE POLICE ORPHANAGE

In former times, policing could be a precarious business – as many would testify that it is today – with a number of police officers dying in the course of their duties. The idea of a police orphanage was first mooted in 1887. The suggestion received the full backing and approval of the head constables of Liverpool, Manchester and the West Riding.

Following a number of fundraising initiatives, the Liverpool and Bootle Police Orphanage was founded in 1894 with the specific aim of providing care for the children of officers from the two forces who had died during active service. When the concept of the orphanage was communicated to serving officers, a total of 1,400 officers, out of a combined police strength of 1,700 officers, agreed to give ongoing support to the orphanage. There was an initial entrance fee of 5s (25p), which was paid by every subscribing member, followed by a weekly subscription of 1d. The general public also contributed to the fundraising, which ultimately enabled the Liverpool & Bootle Police Orphanage committee to purchase, outright, Sunnybank in 1896 for £2,650. The property, which was situated in 6 acres of land along Chapel Street – now known as Speke Road – was the property where Joseph Penlington had lived and from where he had conducted his business as a watch and chronometer maker. The property was sold by his daughter.

A significant amount of conversion work was necessary to make the house suitable to act as an orphanage. The Countess of Derby opened the orphanage on 6 October 1896, when it became 'home' to thirty children. Further extensions were made to the orphanage in 1907.

By 1957 much of the orphanage's role had become redundant and the decision was taken to vacate the property and dispose of the site. Interest was expressed by both the Liverpool City Council and the Marie Curie Memorial Foundation. Eventually, it was agreed that the council would purchase the south plot in order to build a much-needed school, while the Marie Curie Memorial Foundation would take the smaller

north plot that included the orphanage building itself. Once again the building underwent significant modifications in order to make it suitable to accommodate fifty-four patients – later reduced to thirty patients – needing convalescent or long-term nursing care. The Marie Curie Home was opened in 1959. Over time the orphanage building itself became unsuitable for current care practice and standards. A fundraising campaign was started and a completely new hospice was opened in October 1992, having two wards with thirty inpatient beds.

The original Sunnybank orphanage building was demolished in the early 1990s.

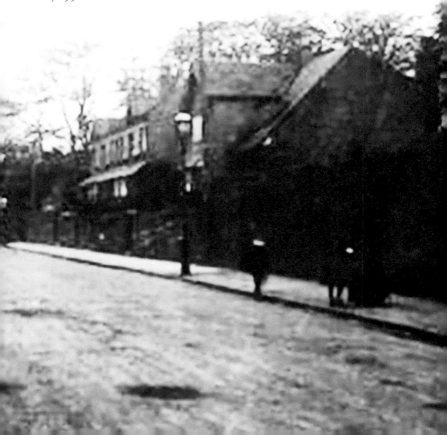

4. WOOLTON STREET

Woolton Street, as its name suggests, is one of the oldest streets in the village. High Street can be seen on the right-hand side of the photograph. The land immediately behind Woolton Street is Woolton Woods. The street is still primarily residential, but the man standing in the photograph might find it difficult to recognise today. The building next to him was home of the first post office in Woolton, which was opened in 1826. The building was demolished in 1952.

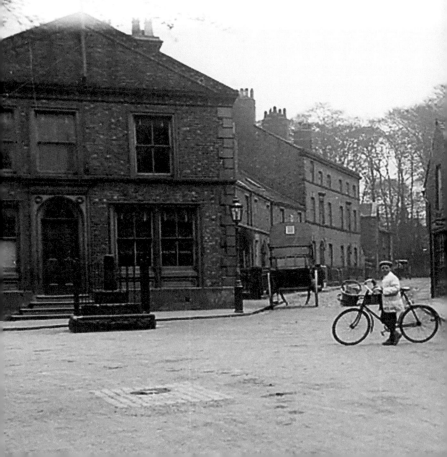

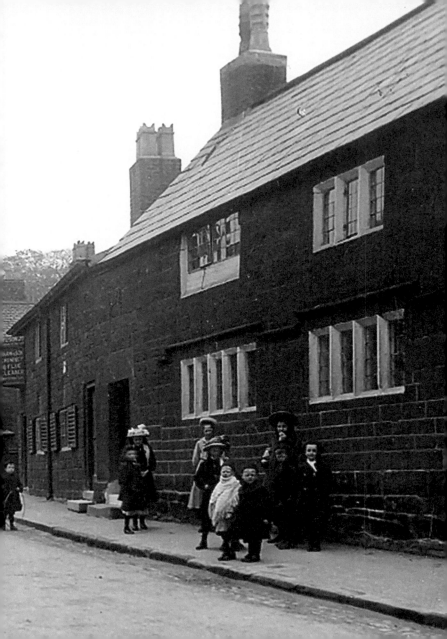

5. WOOLTON TRAM TERMINUS

An Act of Parliament in 1868 gave authorisation for the Liverpool Tramways Company to operate a tram system in Liverpool. The company commenced operations in November 1869 with a total of sixteen horse-drawn trams, many of which had been built in Birkenhead by George Starbuck, and the remainder brought over from America.

Following the passing of the Liverpool Corporation Tramways Act of 1897 the corporation bought the Liverpool United Tramway and Omnibus Company. The first electric tram services commenced in November 1898 and, following an extensive programme of modification, the system was completely electrified by 1902.

Trams were a feature of life in Liverpool for over eighty years, but the increasing popularity of buses and affordability of private cars ultimately secured their demise. During much of that time it was possible to travel on tram 4W from the Woolton terminus, via Wavertree Road, to the Castle Street terminus, and, similarly, boarding tram 5W took passengers from the Woolton terminus, via Smithdown Road, to the Castle Street terminus.

At the end of the Second World War the decision was taken to replace the tram network, route by route, over a ten-year period. The transition started in 1947 and the last tram, car 293, following route 6A, one of the two remaining scheduled routes, departed from the Pier Head terminus at precisely 1.53 p.m. on Saturday 14 September 1957 bound for the Bowring Park terminus, thus relegating the entire system to an ignominious end for failing to take advantage of the twentieth-century urban tram rejuvenation.

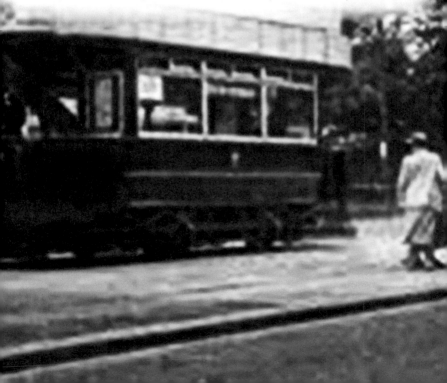

6. HIGH STREET

Running parallel with the perimeter of Woolton Wood, High Street has for many years been one of the main thoroughfares in Woolton. However, the volume of traffic now is somewhat greater than what it was when these two young women were photographed.

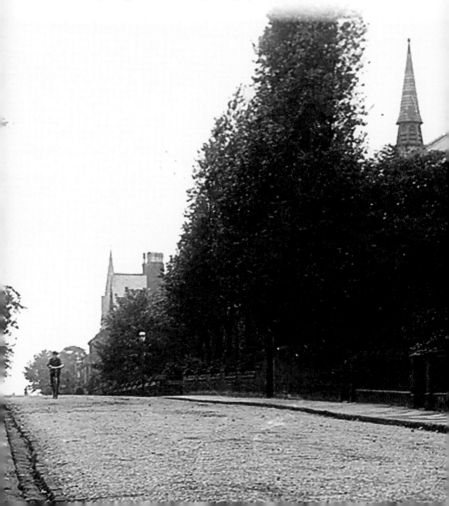

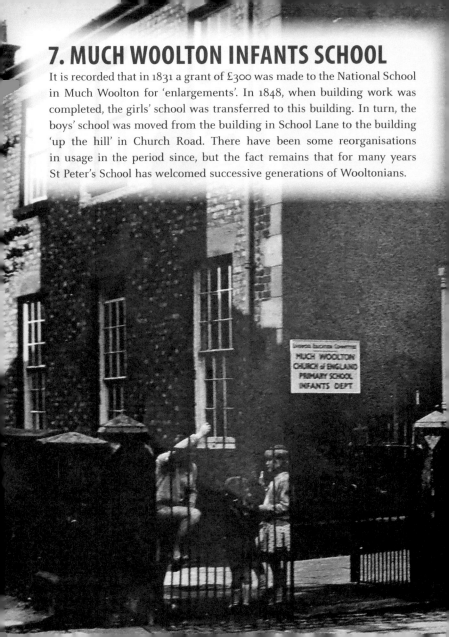

7. MUCH WOOLTON INFANTS SCHOOL

It is recorded that in 1831 a grant of £300 was made to the National School in Much Woolton for 'enlargements'. In 1848, when building work was completed, the girls' school was transferred to this building. In turn, the boys' school was moved from the building in School Lane to the building 'up the hill' in Church Road. There have been some reorganisations in usage in the period since, but the fact remains that for many years St Peter's School has welcomed successive generations of Wooltonians.

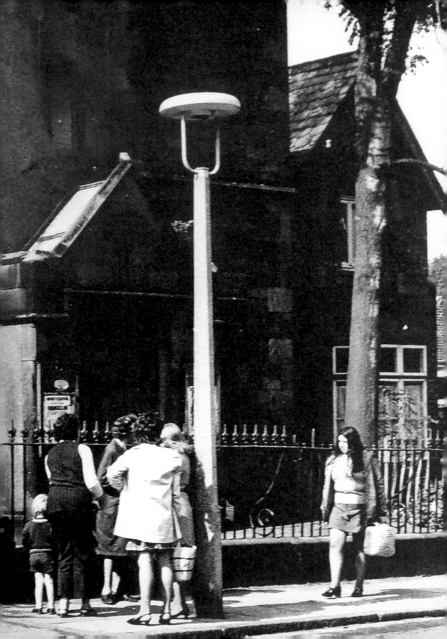

8. CONGREGATIONAL CHURCH

It was in 1856 that a group of Congregationalists, or Independents as they had become to be known, first held a service of worship in the Mechanics' Institute. They continued to hold regular services there for a further nine years. Sometime later a parcel of land was acquired on the corner of Quarry Street South and High Street. The foundation stone for their church was laid in 1864 and the church itself was opened in 1865. Two years after the church opened Revd William Davies was appointed as its minister, and it is true to say that during his twenty-six-year ministry, which lasted from 1867 until his early death in 1893, he was the instigator and driving force behind many of the radical changes that were introduced into the church. It wasn't long before a schoolroom was opened, a bible study group was started and weekday services were being held. Revd Davies was also particularly conscious of the cultural needs of the wider community in Woolton, and he soon had a public library opened in the village, after appointing a qualified librarian. He also organised for a concert to be held every Saturday evening in the schoolroom, and helped to initiate a number of cultural/educational schemes, which were held in the Village Club.

In 1972 the worshipping community in the church joined with the English Presbyterian Church and became known as the United Reformed Church. Unfortunately, due to significant amounts of dry rot, the church was closed for worship and the congregation joined with worshippers at St James' Methodist Church, a little way further along High Street.

Following major refurbishment and reconfiguration, the church building was transformed and reopened as Woolton Grange Care Home.

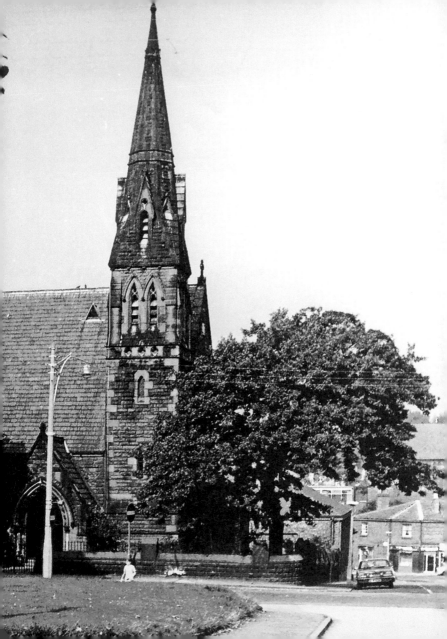

9. CONVALESCENT HOME

The Liverpool Convalescent Institution – as it was originally known – was built as a result of there being surplus funds from the Liverpool Fund for the Relief of the Cotton Famine in 1862. The hospital, designed by Thomas Worthington, was built in 1869 in 20 acres of grounds. By 1882 it had 120 beds, which included both women's and men's wards. Initially, it was intended that the home should be used as a convalescent home for people who had previously been treated in Liverpool's hospitals. There was a cost to patients of 10s a week (50p), which covered food and medicine.

The convalescent home is now known as Woolton Manor Care Home and is a privately owned care home that also offers nursing care.

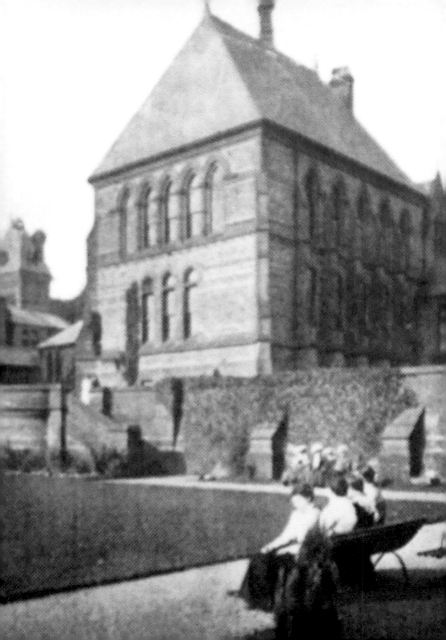

10. WOOLTON WOOD

It was in 1917 that Col James P. Reynolds of Dove Park (Reynolds Park) purchased the 22-hectare estate known as Woolton Wood from the Gaskell family, the then owners of the estate. The entire estate was purchased for the princely sum of £12,000. Col Reynolds was the last private owner of the estate. Ultimately, he sold most of the wood to Liverpool Corporation, but, in acknowledgement of having lived for over fifty years in this most beautiful part of the city, declared that a 10-acre strip of land fronting Woolton Wood on the north-easterly side at High Street should be used as a recreation ground for local people. Still, on every day of the year, local residents enjoy his bequest.

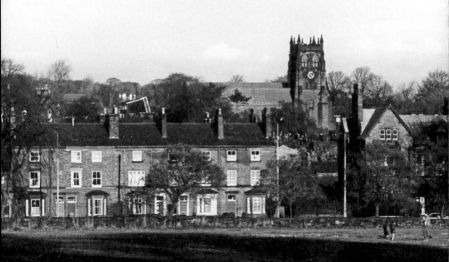

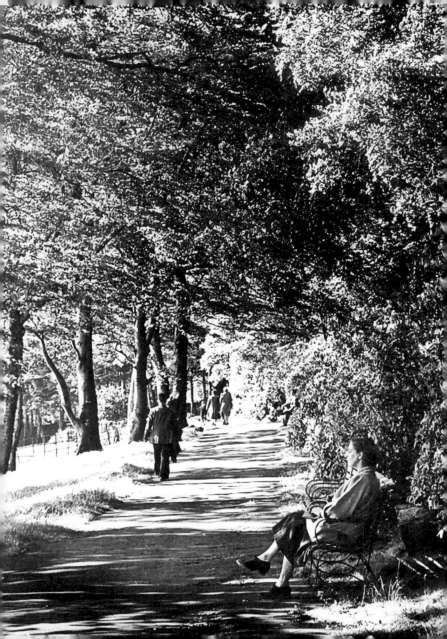

11. FLORAL CLOCK IN WOOLTON WOOD

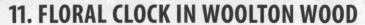

The Floral Cuckoo Clock in the Old English Rose Garden in Woolton Wood is still one of the most popular attractions of the wood.

In 1871 the Gaskell family was resident at Woolton Wood, and it was some years later, in 1927, that the family of James Bellhouse Gaskell presented the Floral Cuckoo Clock to the people of Liverpool in memory of his long connection with Woolton Wood.

The walled garden, which is 'home' to the cuckoo clock, is, sadly, all that remains of the mansion owned by the Gaskells.

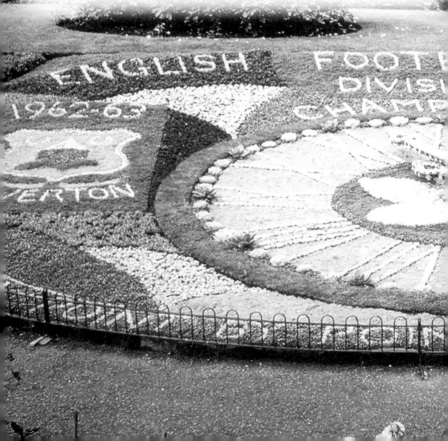

12. THE OLD SCHOOL

Many myths and legends are told about the Old School in School Lane – some of which are difficult to substantiate. What cannot be disputed, however, is the fact that the school building is the oldest of its type in Lancashire (that is Lancashire prior to the boundary changes of 1974). The inscription in the sandstone lintel suggests that the school was built in 1610, but registers at All Saints Church in Childwall date the building at 1597. There is even some evidence stating that a building of some description was used for educational purposes as early as 1575. Fittingly, the building is now home to a nursery, serving the earliest educational needs of Woolton's next and future generations.

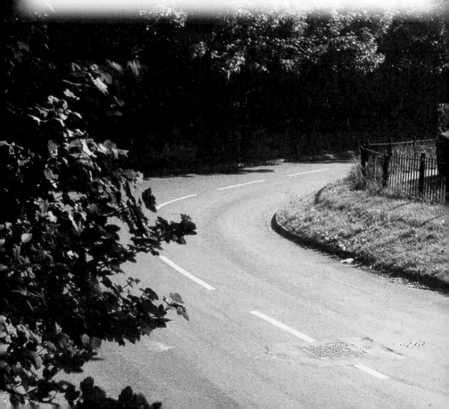

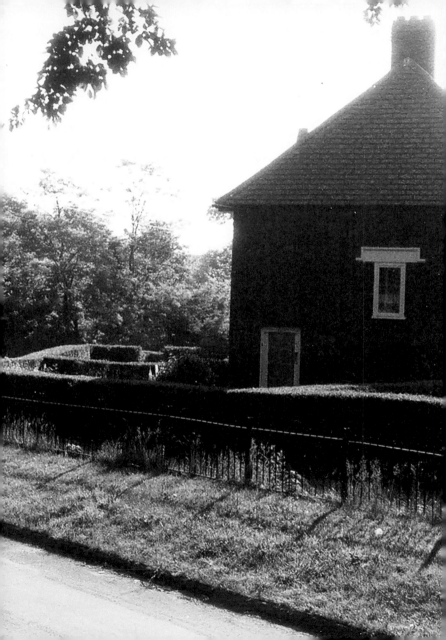

13. PUDDING BAG SQUARE

Ashton Square – named after Nicholas Ashton, one of the former owners of Woolton Hall – was previously called Pudding Bag Square. That name came about because many of the village's black puddings were made in that vicinity. The hall's butler lived in the Fabric Cottage near to Ashton Square, and estate workers and grooms lived in the square itself. Today, the square is at the centre of a quiet residential area and, to outward appearances, looks very much as it did all those years ago.

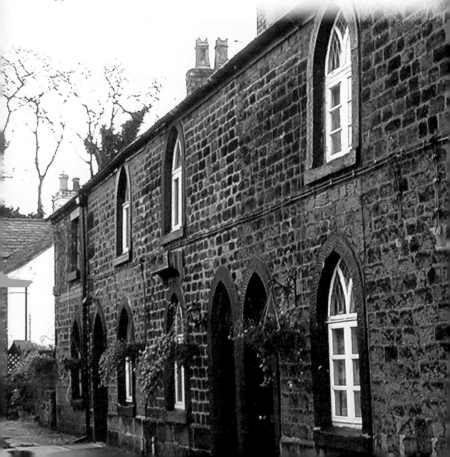

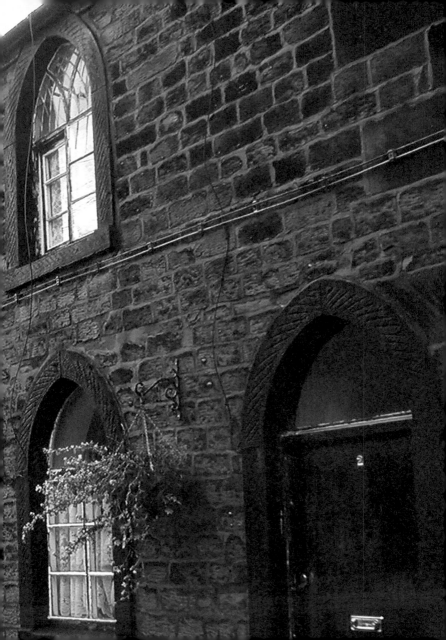

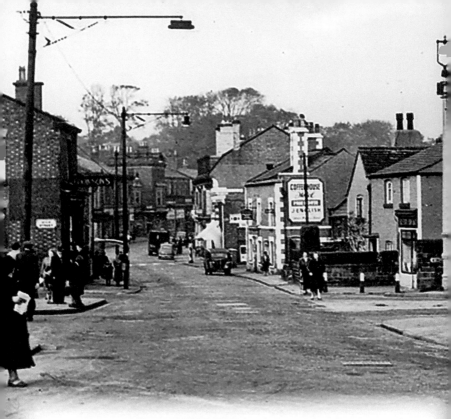

14. WOOLTON CROSS

It is believed that Woolton Cross, which is perhaps the oldest man-made object of any significance in the village, was erected somewhere in the region of 1350, but there is no definitive record of the exact date. The cross marked the northern boundary of the village – a similar one, Hunts Cross, marking the southern boundary. Many years ago, at an unknown date, the cross was broken; but in 1913, when Woolton was incorporated into the city of Liverpool, Arthur S. Mather was commissioned to restore the cross in celebration of that event.

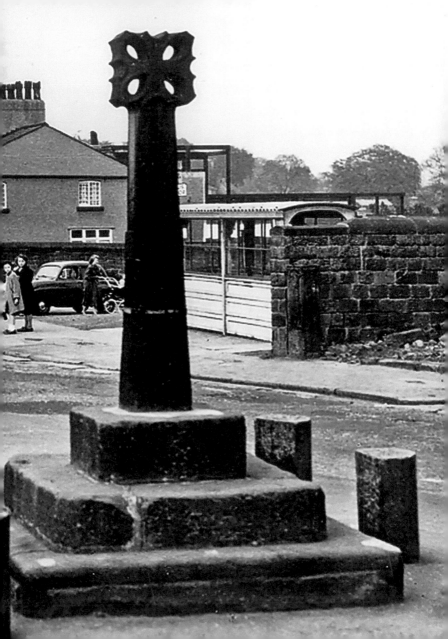

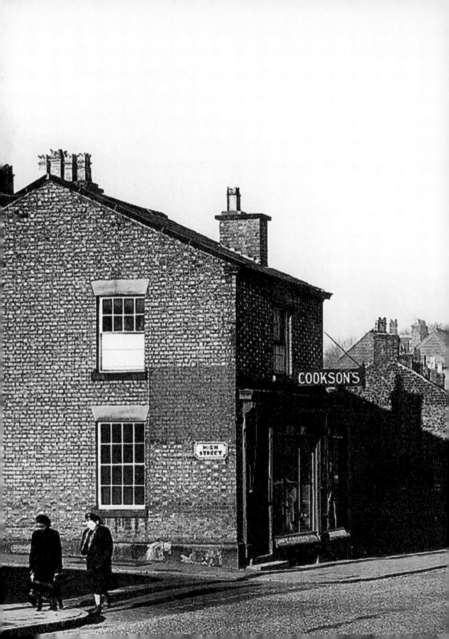

15. WOOLTON STREET

Woolton Street, perhaps the main through road of the village, has been a feature of the village for centuries. Cattle, sheep and pigs were once driven along Woolton Street, either on their way to market or the nearby abattoir. Today the scene is very different, and, more often than not, there are traffic jams along the narrow road.

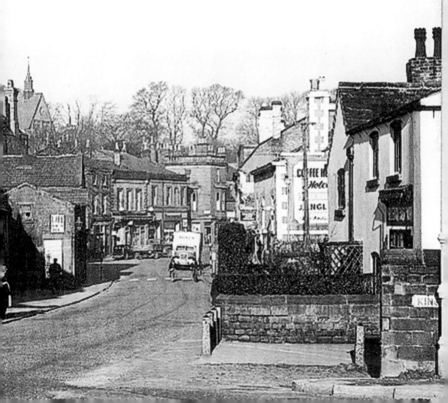

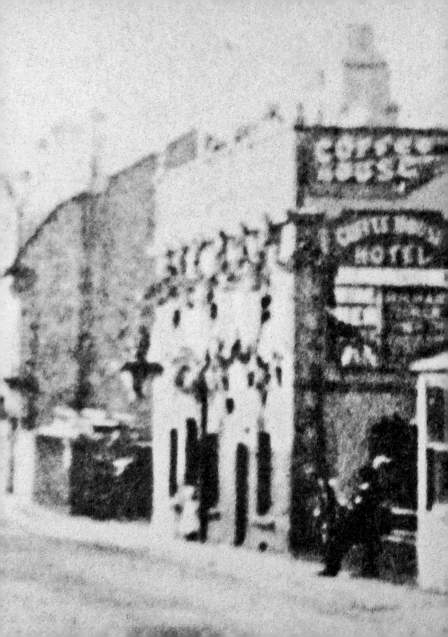

16. THE COFFEE HOUSE

The Coffee House is reputed to be one of the oldest pubs, if not the oldest pub, in Liverpool. The date of the side of the wall declares that it was built in 1641. Woolton's three-day annual festival, Woolton Green, was held each June behind the Coffee House.

17. JUNCTION OF WOOLTON STREET, ALLERTON ROAD AND ACREFIELD ROAD

As early as 1833 there was a regular horse-drawn omnibus service operating between the centre of Liverpool and both Woolton and Gateacre. Some two years later a Woolton man started an hourly omnibus service between Liverpool and Woolton, passing through Wavertree. Services normally started and terminated at Lodes Pond. In 1911 most of the omnibus services to and from Woolton were taken over by Liverpool Corporation.

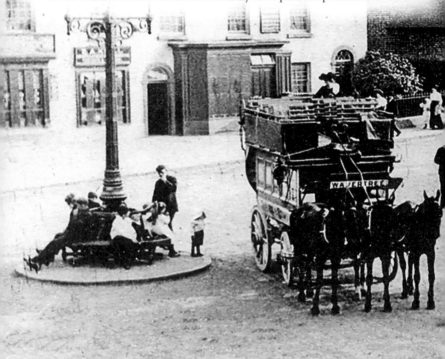

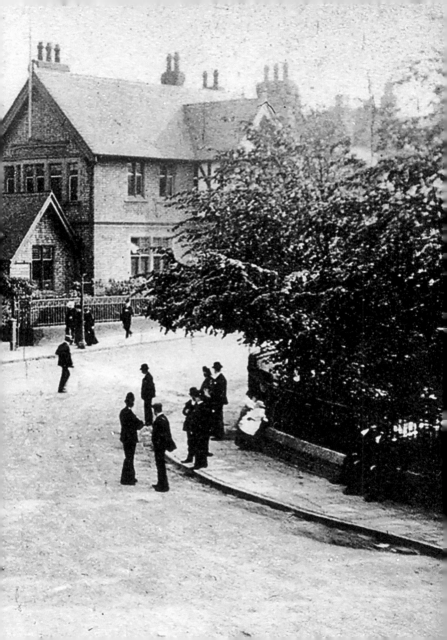

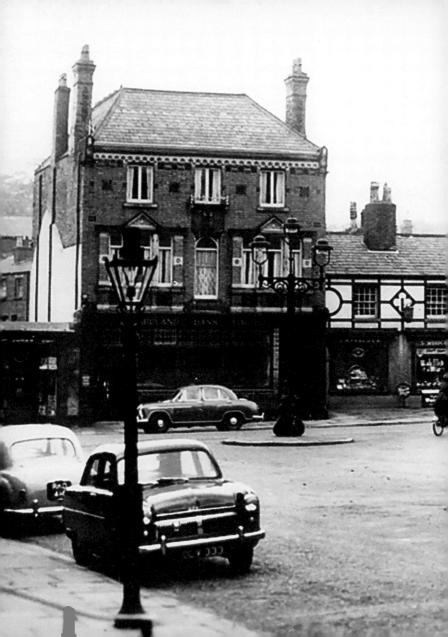

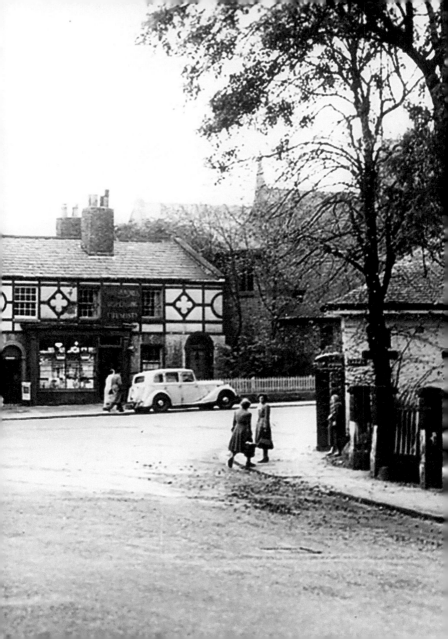

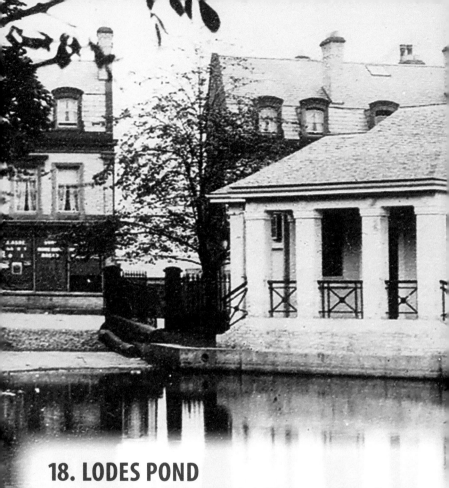

18. LODES POND

A minute from the Local Board of Much Woolton records the fact that 'the Marquess of Salisbury gave and granted to the Local Board the land known as the Lodes in the township of Much Woolton as the same was then fenced in by a wall and iron railings and partly used as a watering place for cattle and partly as a shrubbery and pleasure ground upon trust that the Local Board and their successors should for ever maintain

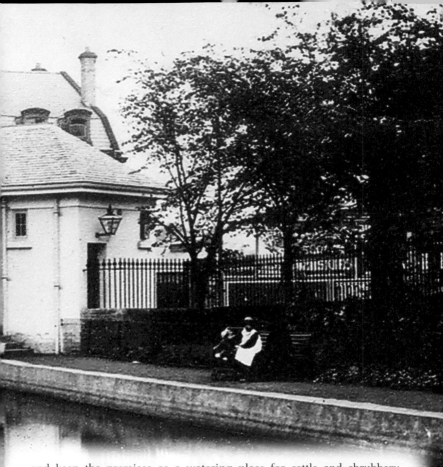

and keep the premises as a watering place for cattle and shrubbery and pleasure ground for the use and benefit of the inhabitants of the township of Much Woolton'.

The fountain in the centre of Lodes Pond was once a central feature and added attraction for the pond. However, in those days, well before the end of the nineteenth century, the pond and its 'shrubbery' were always a popular meeting place for the villagers of Woolton. Today Lodes Pond helps to alleviate the parking problems in the village.

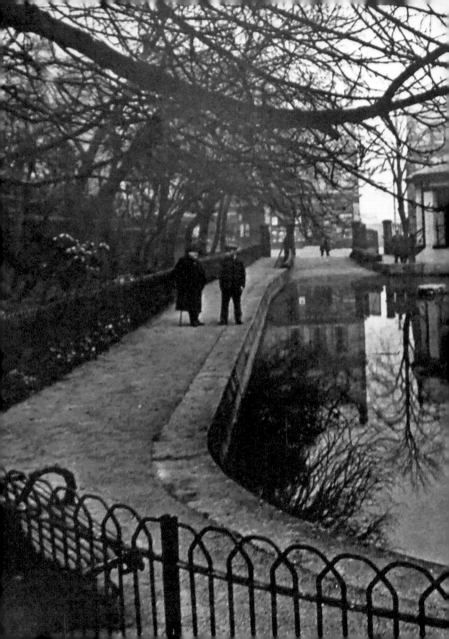

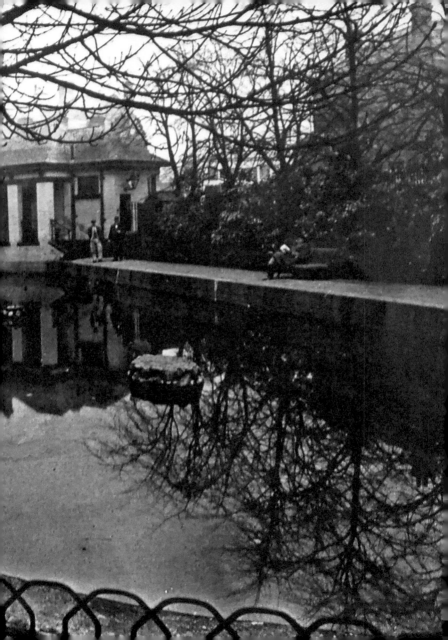

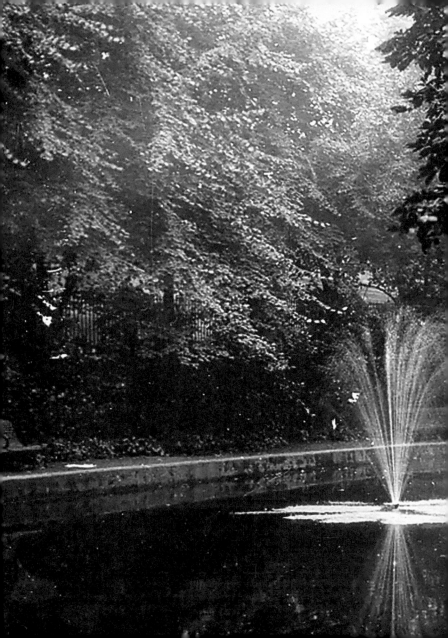

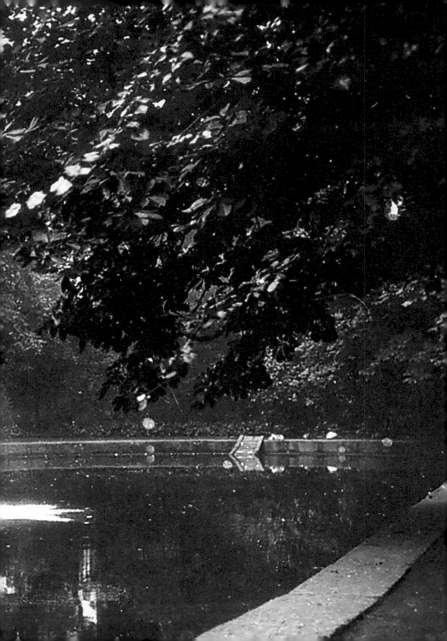

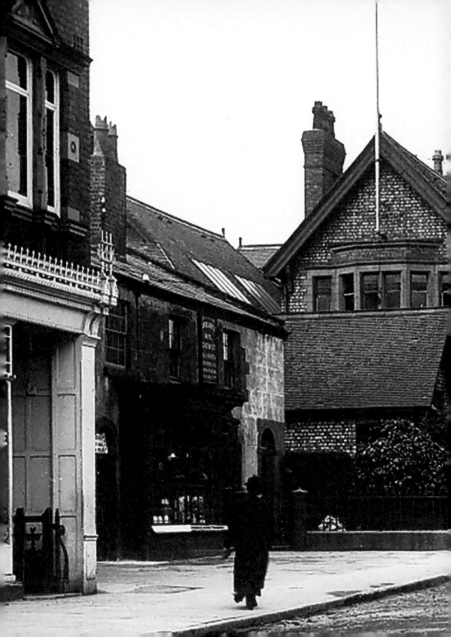

19. ALLERTON ROAD

In many respects, the view along Allerton Road today is very similar to what it was at the turn of the nineteenth century. Many of the buildings are still there, but it's not very often that pigs are seen trotting along the road now (see overleaf)!

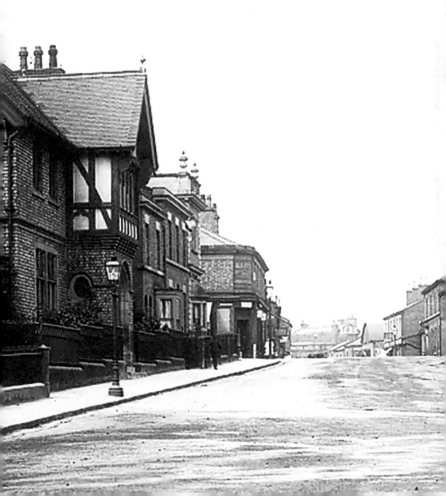

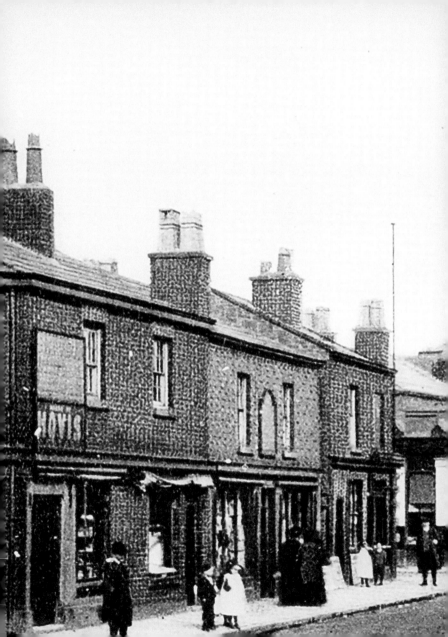

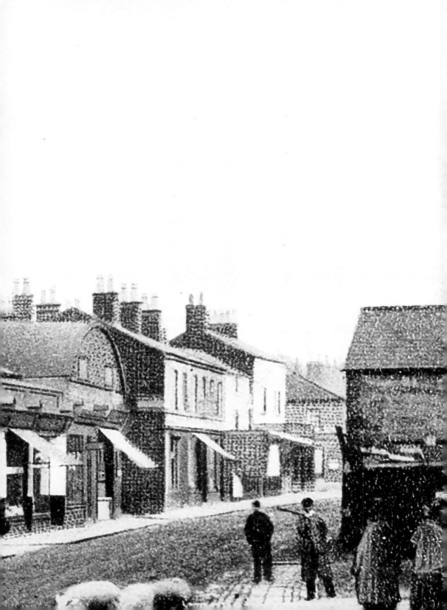

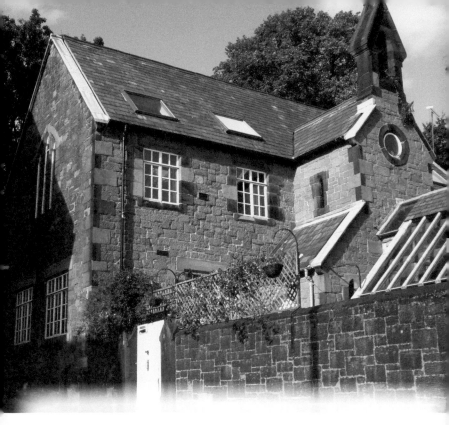

20. THE MECHANICS' INSTITUTE

The Mechanics' Institute, or the 'Mechanics' as it was known locally, first opened its doors in 1849 and continued, in one form or another, until 1928. During that time it was used for many purposes: Band of Hope rallies, spelling bees, schoolroom, mutual improvement meetings, police court, political meetings, and a large number of other functions. Indeed, in the severe winter of 1874, when many local workmen couldn't find gainful employment, the 'Mechanics' was used as a soup kitchen. During an eleven-day period in excess of 400 people were fed, twice every day, with a bowl of soup and a slice of bread.

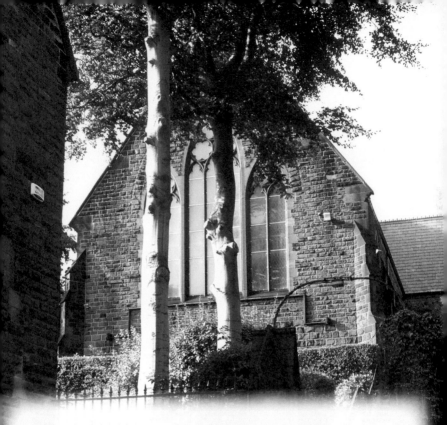

21. ST MARY'S CHURCH

In 1766 Dom Bernard Catterall, chaplain to the widowed Viscountess Molyneux of Croxteth, was given 12 acres down Watergate Lane to provide for a mission to be established. Previously, the mission had been served from Woolton Hall. St Bennet's Priory was built, but with the influx of large numbers of immigrants in the nineteenth century, the congregations swelled. The priory was twice enlarged, but, ultimately, it was decided that a new church must be built. St. Mary's was built in 1860 and a linked presbytery added in 1870.

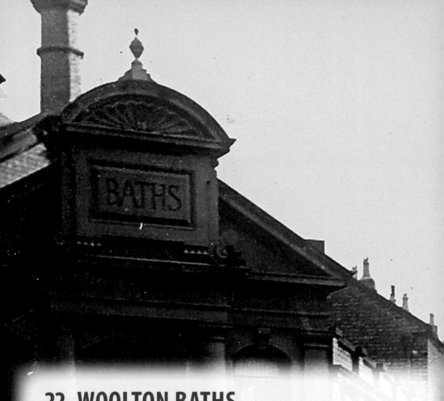

22. WOOLTON BATHS

In the year 1891, being somewhat dismayed at the lack of bathing facilities 'within the reach and the means of the labouring classes of the village and neighbourhood', local resident and philanthropist Mr Holbrook Gaskell JP made a generous proposition to the Local Board, in which he offered to build a public baths – at his own expense – for the people of Woolton; there was, however, a number of provisos, the first being that the Much Woolton Local Board would be responsible for the maintenance of the building, as outlined in the Baths and Washhouses Act of 1846. In order to achieve his stated aim of improving sanitation for the residents of the village, Mr Gaskell also stipulated that the baths should be available to both sexes and all classes.

The architects for the baths were Horton & Bridgford of Manchester, who had previously carried out work for Mr Gaskell when they designed the Widnes Baths (now demolished). Isaac Dilworth of Wavertree was the contractor for Woolton Baths, and the engineering work was carried out by Messrs Bradford & Co. of Manchester and Salford.

The land upon which the baths were built was supplied by the Local Board and built at a cost of £3,300. When the baths opened to the public in June 1893 they included six private baths, a footbath, a plunge pool and a laundry, as well as the swimming pool itself. The water for the baths was supplied from Woolton Reservoir and, as with other public baths at the time, the water in the pool was only changed once a week. The baths superintendent varied the admission fee accordingly – the entrance fee was cheaper at the end of the working week when the water was dirtiest!

Along Allerton Road the baths abutted onto a building that is believed to have been used as stables. Up until 1913 the building was used as a fire station where a handcart fire appliance was kept. The building later became an integral part of the baths and was used to house plant equipment for the baths. It also served as a workshop and storage area.

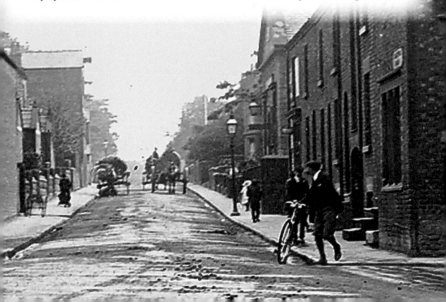

23. THE GRAPES INN, ALLERTON ROAD

The Grapes has stood opposite to Woolton Baths for as long as anyone can remember. It's still a very popular pub in the centre of the village, lying as it does at the crossroads between Allerton Road and Quarry Street.

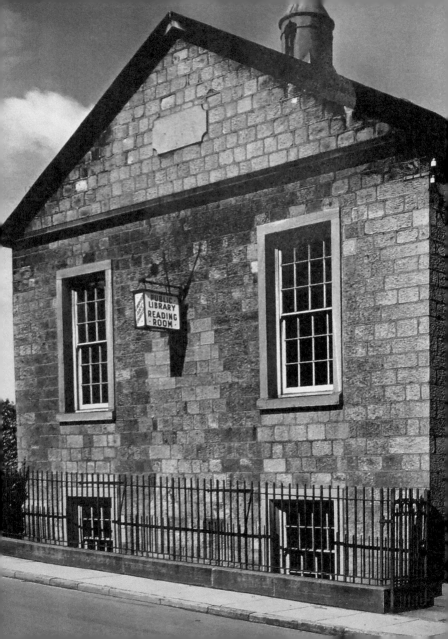

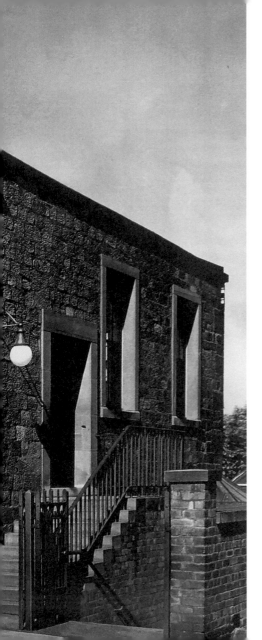

24. THE WOOLTON LIBRARY

The library in Woolton was originally built as a Wesleyan chapel in 1834. In fact, it was the first Wesleyan chapel to be built in the village. The chapel was used for thirty-two years, but with gentrification and an increase in the village population, the building became too small. When St James' Church opened, the chapel was used as a Wesleyan day school and as a Sunday school. The building subsequently became the home of Woolton Library, which opened in 1926.

25. QUARRY STREET

Sandstone quarries have been a feature in Woolton's landscape for centuries. There were quarries at Woolton Hill Road, School Lane and Quarry Street, to name but three. Quarry Street itself was once the home to many of the men and women who worked at the various quarries in and around the village – perhaps most notably the north and south quarries further along the street. The sandstone here was of a particularly good quality, and, because of this, was used to build many of the grand houses and mansions in the Woolton area.

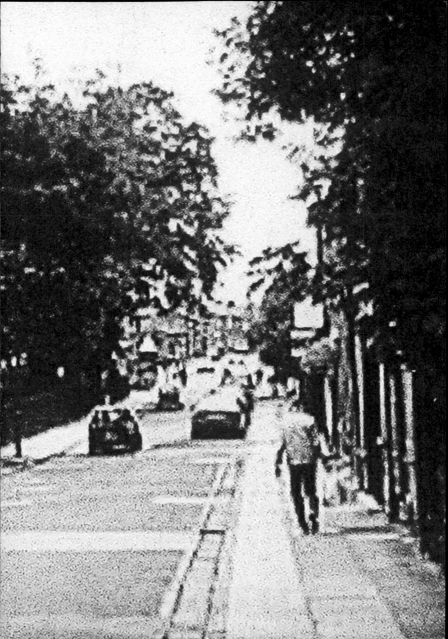

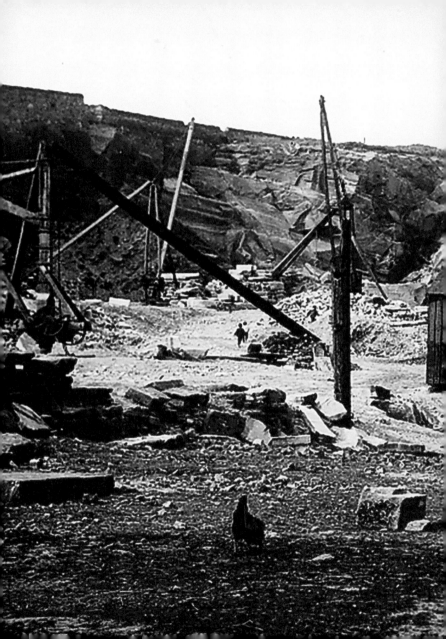

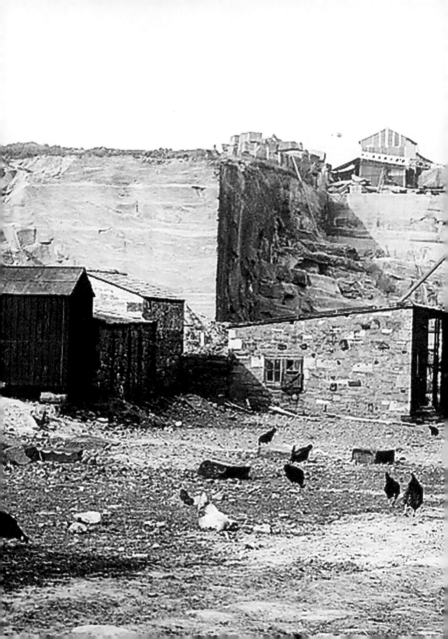

26. MILL STILE

Of the many quarries being worked in and around Woolton, it is the quarries situated between Quarry Street and Church Road that, perhaps, are most noted. The two quarries were separated by a public footpath that is still known as Mill Stile, the mill being located in Church Road.

Although quarrying had started before 1870 to the north of the Mill Stile, it was not until 1905 that stone was excavated for the building of the Anglican cathedral in Liverpool. Sometime later, in 1934, the Marquess of Salisbury – then owner of the quarry – made a gift of the 6.5-acre quarry freehold to the Cathedral Committee, thus ensuring that the building of the cathedral would be completed to a uniform standard.

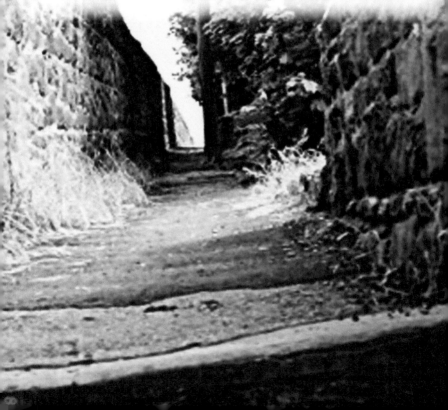

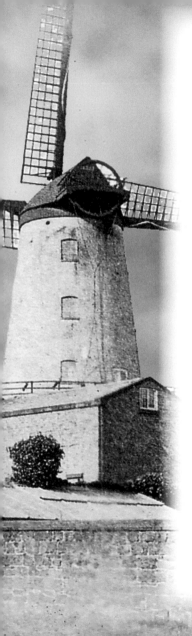

27. WOOLTON WINDMILL

It is believed that James Rose was born in 1783. In his early life Rose was a miller in the nearby village of Garston. In 1806 he married a lady of some considerable wealth – owning seven windmills in her own right. Having significantly enhanced his financial status, Rose continued to build a sizable portfolio – mainly focused in and around Woolton – his principal interests being quarries and farmlands. After constructing Church Road, Rose built a windmill in 1810. Later, in 1835, he revolutionised the mill by introducing steam power. The venture proved to be profitable, so Rose invested in more land and sandstone quarries. However, Rose's business ventures did not end there; he built Rosemont where he lived in for many years. He also built Beechwood, which subsequently became Archbishop's House. Rose Street and Rose Brow also bear the name of this prominent resident.

Rose is widely acknowledged to have transformed the village from barren land into good farmland and parkland. When he died in 1860, the bells of St Peter's were tolled continuously for three days.

Little evidence of his mill remains today, but part of the perimeter wall can still be seen near to the Mill Stile.

28. CHURCH ROAD

Church Road, since James Rose planned and built it, continues to be one of the busiest roads in the village and is still at the very heart of Woolton.

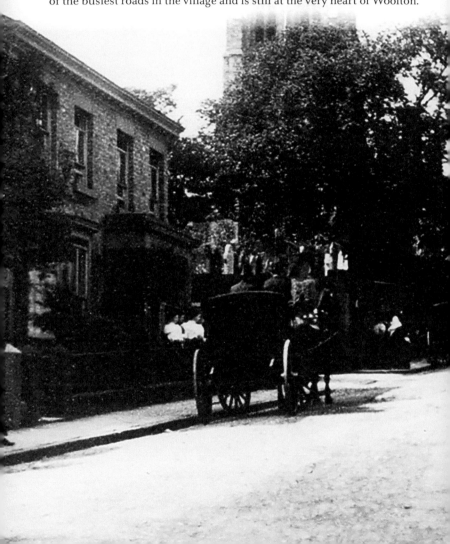

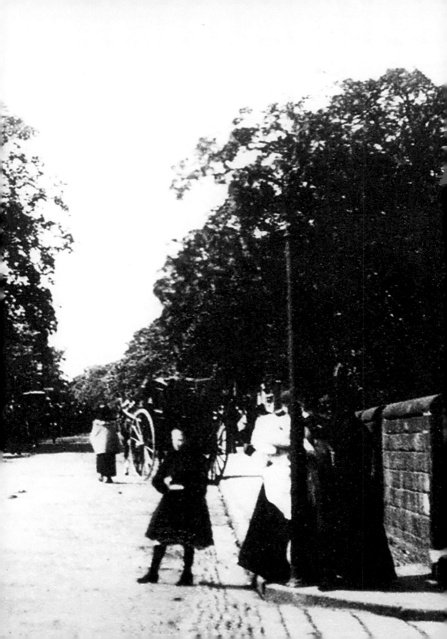

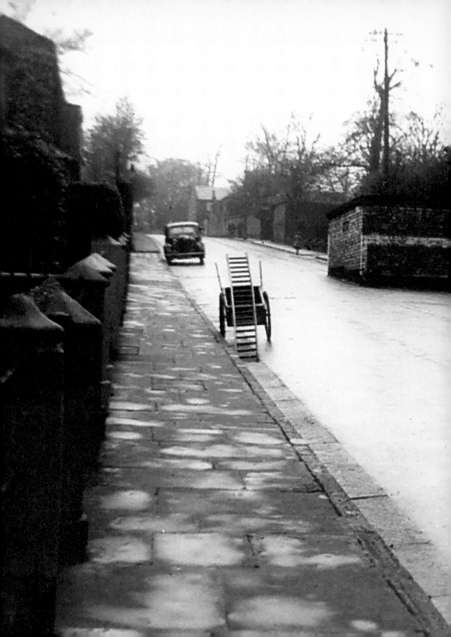

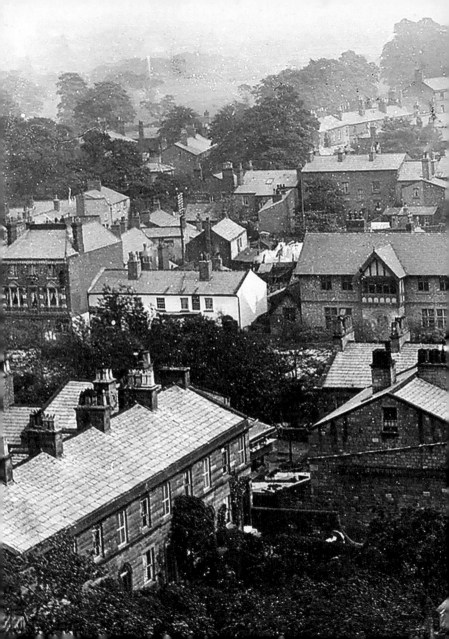

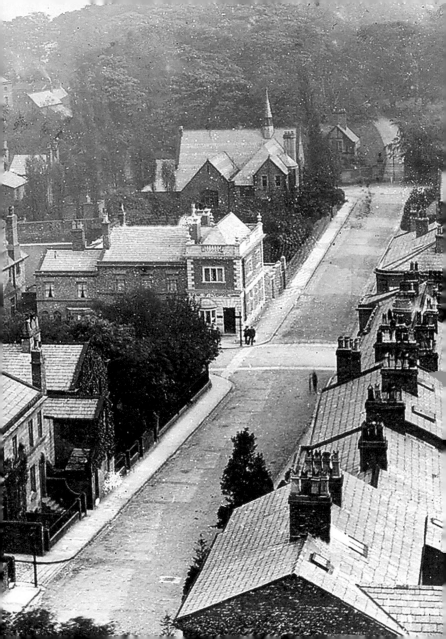

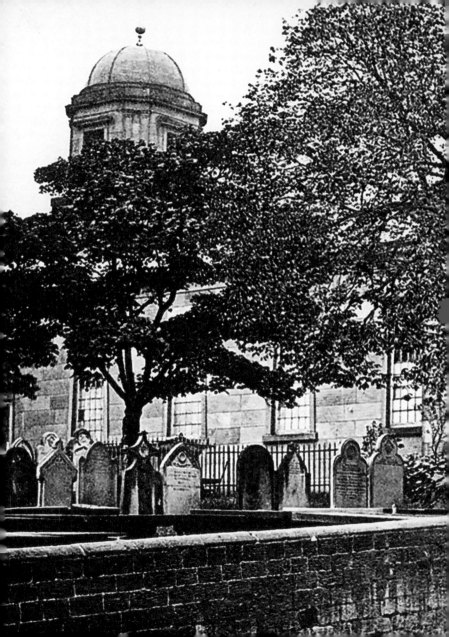

29. THE OLD ST PETER'S CHURCH

With the increase in trade and industry in and around the village, there was a corresponding increase in the population, which in turn gave rise to the need for more social amenities, including a suitable place of worship. The first church of St Peter, built from locally quarried sandstone and holding around 200 people, was consecrated in 1826. Before that time, worshippers had to travel to the church in Childwall – a round trip of around 6 miles. Revd Robert Leicester was the church's first incumbent, serving the parish for forty-nine years. During his long incumbency he gave many gifts to the village, including the village's central street lamp and the drinking fountain at the bottom of Church Road.

30. ST PETER'S CHURCH

With the steady rise in population in the village and the subsequent rise in congregations, it was considered that a larger church should be built. The foundation stone of the present church of St Peter was laid in 1886, and the church opened during the following year. Like so many other buildings in the area, the church of St Peter was built from sandstone quarried in Woolton. However, the old church was dismantled, stone by stone, and rebuilt as the parish hall of St Cleopas in Mill Street.

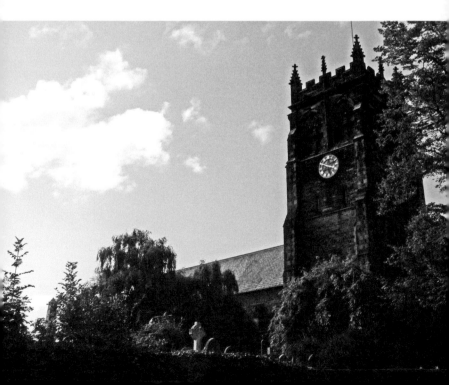

31. THE BOYS SCHOOL

Before the Education Act of 1870, a number of charitable organisations were the main providers of education. The building that is now known as the Simon Peter Centre was previously the Church of England Junior School, and before that it was known as the Boys School. The school was built on enclosed land on the Common, adjacent to the workhouse. It is believed that the school became established in 1820, and that the school itself was opened in 1821, although the building work was not completed until 1823. Prior to that date, part of the workhouse was used to educate

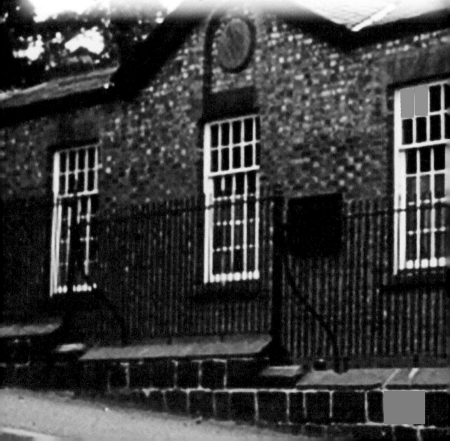

the girls of the village – the boys were still being educated in the old school in School Lane. However, sometime later, provision was made for an infants' department. The building was completed in 1848 and at that time the girls' school was transferred there; the boys left the School Lane building and moved to what was to become the Boys School.

The Simon Peter Centre is a multipurpose building, having been completely redesigned and refurbished following the opening of the new Bishop Martin Church of England Primary School.

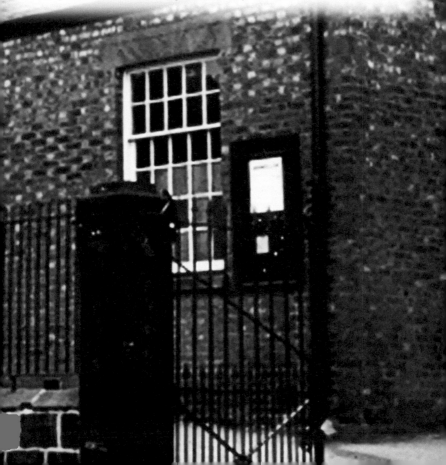

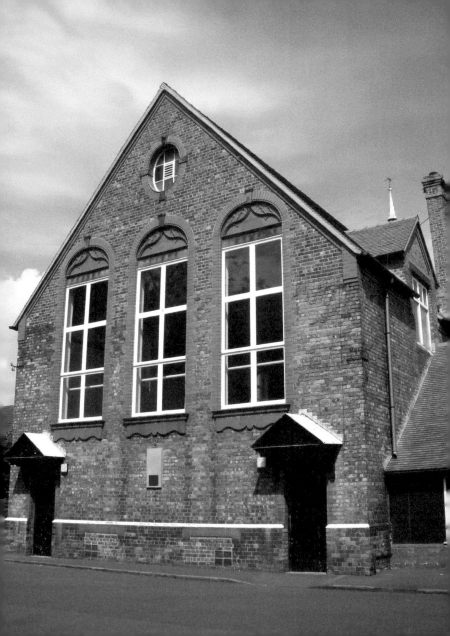

32. ST PETER'S CHURCH HALL

No book about Woolton would ever be complete without making reference to St Peter's Church Hall. It was on the evening of Saturday 6 July 1957, more than sixty years ago now, that members of the Quarrymen skiffle group were waiting to take to the stage. A mutual friend introduced the teenage Paul McCartney to John Lennon and other members of the group. It is recorded that the meeting lasted less than half an hour, but during that brief period Paul impressed the Quarrymen by showing them how to tune their instruments and demonstrating his impressive musical knowledge and ability. A few days later, Paul accepted an invitation to become a member of the group. John Lennon is reputed to have said 'that was the day, the day I met Paul, that it started moving'.

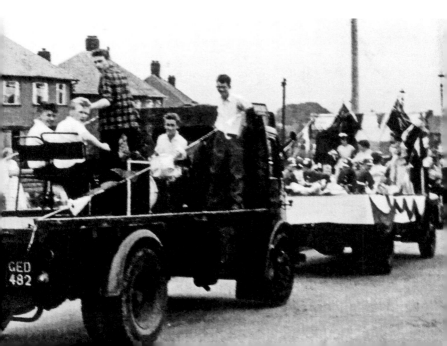

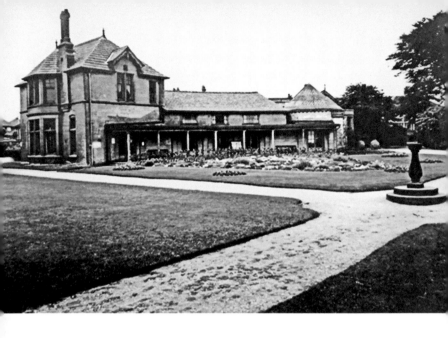

33. REYNOLDS PARK

The original parkland, which is now known as Reynolds Park, provided common grazing land for local people as a result of the Enclosures Act of 1805. Church Road, which lies adjacent to the park, was home to many of Liverpool's great Victorians: people such as Samuel Weston, a Liverpool merchant; John Crosthwaite, a director of the Great Western Railway; and George Cope, whose wealth came from the tobacco trade. However, perhaps James Reynolds is the best-known owner of the estate He was a wealthy cotton broker in Liverpool and, in addition to owning Reynolds Park, he also owned a castle in Wales and Levens Hall in Cumbria.

Since the mansion at Reynolds Park was destroyed by fire, the footprint has been redeveloped into 'sheltered housing' accommodation, and is now known as Calvert Court.

34. THE ELEPHANT HOTEL

The Elephant Hotel, which is a Grade II listed building, was built in the 1800s as a manor house. By 1837 it was known as the New Inn, but later, in the 1850s, its name changed to The Woolton Hotel. Sometime in the 1860s the entrance portico was graced with a statue of an elephant. The hotel was renamed The Elephant Hotel in 1875. The hostelry continues to be one of Woolton's most popular meeting places.

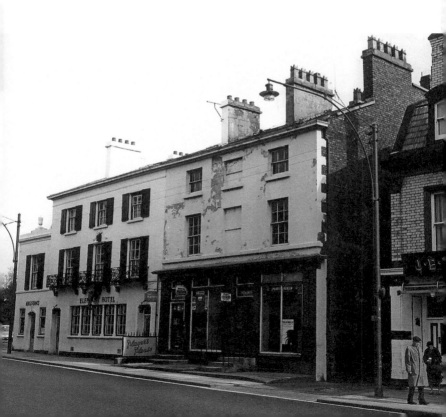

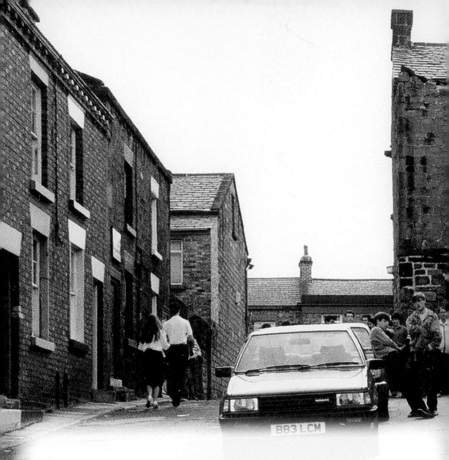

35. THE WOOLTON PICTURE HOUSE

The Picture House, to give it its correct title, is the oldest surviving cinema in Liverpool. The cinema opened on 26 December 1927 with a seating capacity in excess of 800, which included a number of wooden benches. The Picture House has long been known colloquially as 'The Woolton', but there are other nicknames; John Lennon, on the frequent occasions when he visited the cinema, disparagingly referred to it as 'the Bug'!

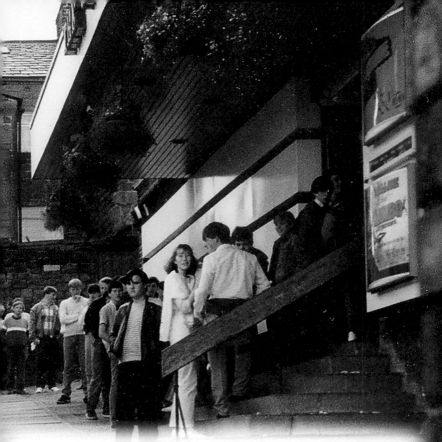

The cinema survived the intense bombing that Liverpool was subjected to during the Second World War and remained open throughout that dark period. On 22 September 1958 there was a major fire at the cinema, which resulted in closure while extensive refurbishment work was carried out. The seating capacity was reduced to less than 600 seats. Then, in the 1980s, when Cheshire County Cinemas owned the cinema, a new wall-to-wall screen proscenium was installed, together with new carpeting and 256 luxury Pullman seats. The cinema is still one of the most comfortable in the region.

36. ROSE BROW

The quarrying of sandstone in and around Woolton, coupled with the wealth accrued from business and trade interests in the nearby city of Liverpool, meant that many prominent businessmen and quarry owners were resident in the village. Some of the more illustrious residents included John Greenough, James Gore and James Rose. Indeed, sandstone from the quarry owned by James Rose was used in the infrastructure of Rose Brow, which still bears his name.

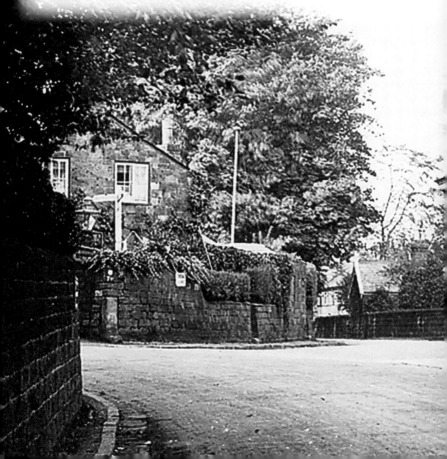

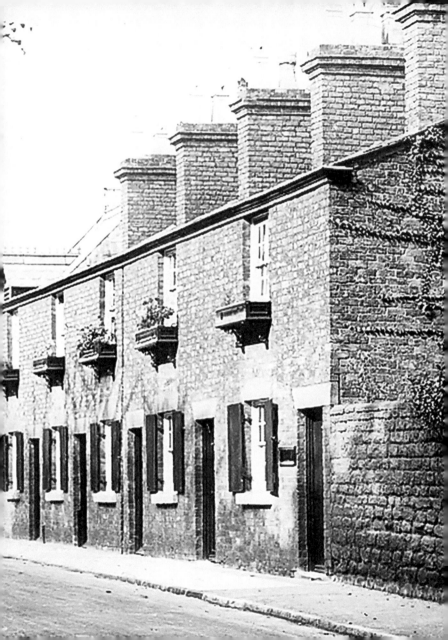

ABOUT THE AUTHOR

David Paul was born and brought up in Liverpool. Before entering the teaching profession David served as an apprentice marine engineer with the Pacific Steam Navigation Company. Since retiring, David has written a number of books on different aspects of the history of Derbyshire, Cheshire, Lancashire, Yorkshire, Shropshire and Liverpool.

Also by David Paul:
Eyam: Plague Village
Historic Streets of Liverpool
Illustrated Tales of Cheshire
Illustrated Tales of Yorkshire
Illustrated Tales of Derbyshire
Illustrated Tales of Shropshire
Illustrated Tales of Lancashire
Speke to Me
Around Speke Through Time
Woolton Through Time
Anfield Voices